Emergo Art Magazine, Issue number one, 2019
Emergo Art Magazine is published monthly, however the issues don't "age",
as the art in this magazine will be as relevant as the art in the next one.

Buy art without commissions.
emergoart.com/exclusive

Featured artists:

Antoine Puisais

• • •

Koen Lybaert

• • •

Frederic Belaubre

• • •

Ingrid Knaus

Would you like to be a featured artist as well?
Visit www.emergoart.com/submit
and submit your art!

Art Magazine

We feature emerging artists.

We consider someone an emerging artist when their art is actually being sold.
When an artist reaches a certain level of success, and they really start
selling their art for a price they can live off of, they become motivated
to try out new techniques, experiment, and by doing that they can
expand their portfolio.

If you are an artist, we want you to know that we believe in you.
We think that you have a shot.
Never stop improving, and never stop learning, and at one point,
if you really want to become a full time artist,
you will.

And to all of the artists that we feature:
We wish you the best of luck with your career.
We hope that we can feature you again, and never hesitate
to ask us any questions.

Antoine Puisais

Process
Before anything else it's important to understand how my system operates. I use matrices
to transfer on to canvas the results of my researches. Matrices are panels of plywood which act as stamps. So that what you see on these canvases is the result of a method of haphazard replication which leaves lots of room for the accidental.
Matrices are constantly reused, covered again and again by several layers of plaster, paint and pigment. New paintings carry the scars of old ones. Old compositions help new compositions, everything is reinterpreted.
But my work does not stop there. Once the painting is revealed, I take pictures of it and transform the images with processing software. A conversation then begins between the digital images and my studio work. Canvases are cut, turned and stuck together until I find harmony between my discoveries and my plans.

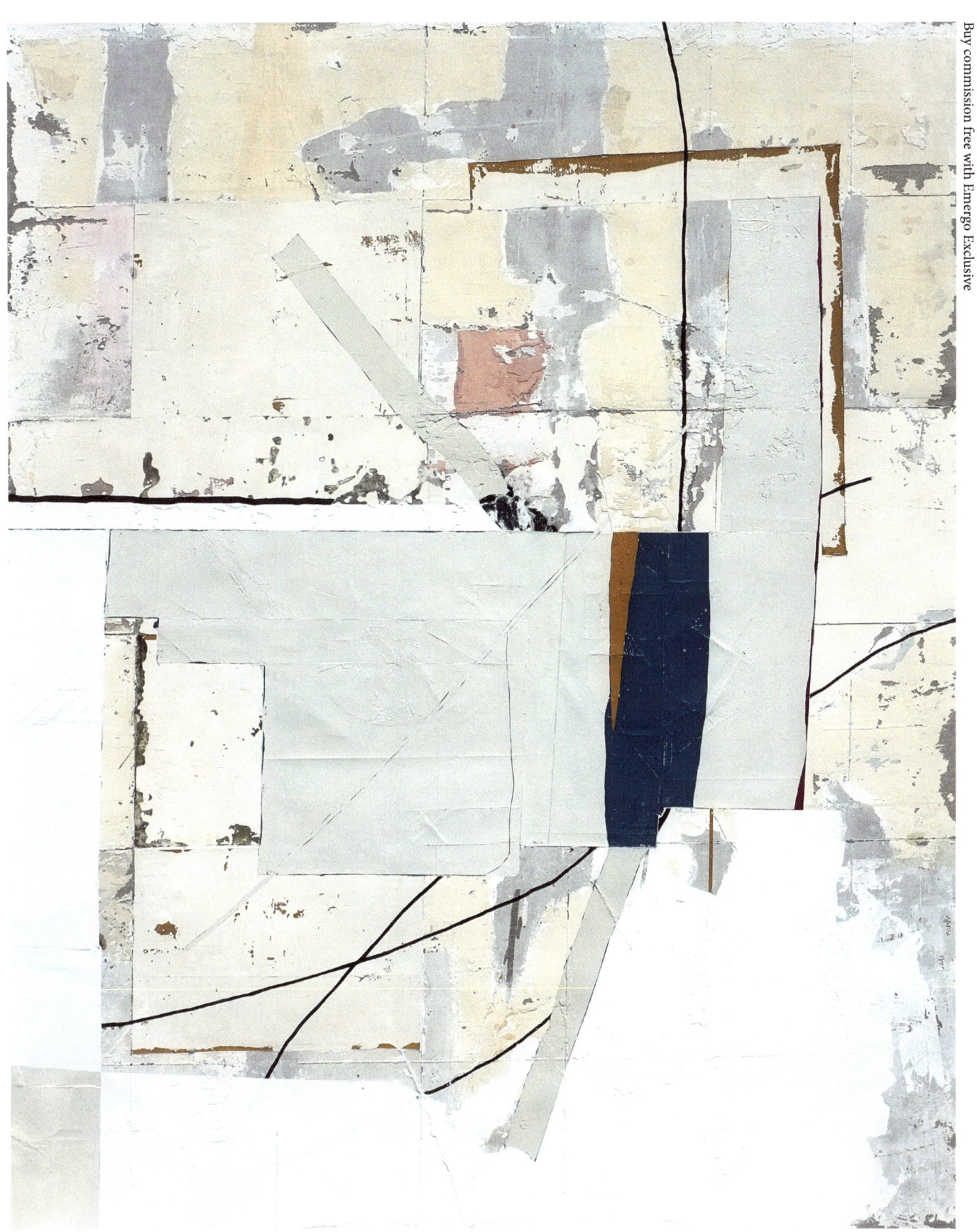

Untitled
Acrylic, Spray Paint, Household and Fiberglass on Canvas and Wood.

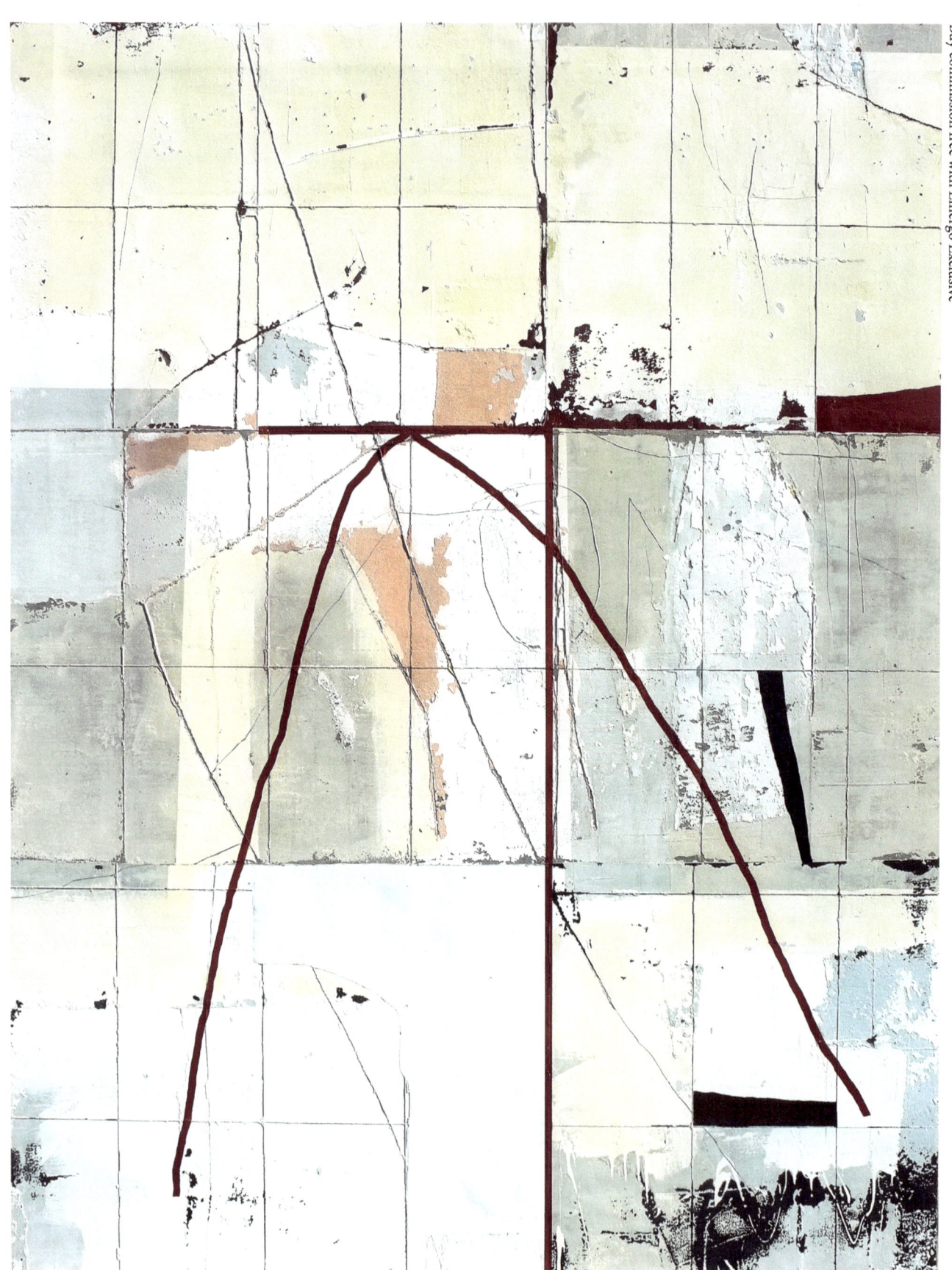

Untitled
Acrylic, Spray Paint, Household and Fiberglass on Canvas and Wood.

I create problems and I solve them

In 1911, Georg Simmel claimed that architecture consists of a balancing act between the upward striving of the human spirit and the destructive forces of natural decay, for him, ruins represent nature's defiant reclamation of her own materials. The ruin is nature's victory over human enter- prise, he wrote, formed when nature transforms the work of humankind 'into material for her own expression'.

This is what happens in my paintings. Look at them, they were repaired. They are vestiges, residues, archaeological finds. They are separate parts striving for unicity.

Each new painting is a playground full of possibilities and pitfalls. Each time, I tear away the canvas from its support, I discover the painting. From there, I act like an archaeologist who digs up elements from the past and connects them in order to understand the present.

The result of this process is an endless procession of "accidents" and errors. I have to adjust to what I discover. I have to deal with organic reality. My project is not meant to show paintings but to show how paintings are conceived and created. To show what's happening behind the last coat of paint. How images slowly fade to reveal structures.

Build, destroy, rebuild
In my work the notion of unfinished is essential. I act in a logic of construction, destruction
and renovation. To seize the key moment between the end and the revival. For me, the act
of painting is always a sweet war between what you show and what you hide, it's a reflection of an interiority and, in this binary act of adding and eliminating, I am interested in what resists.

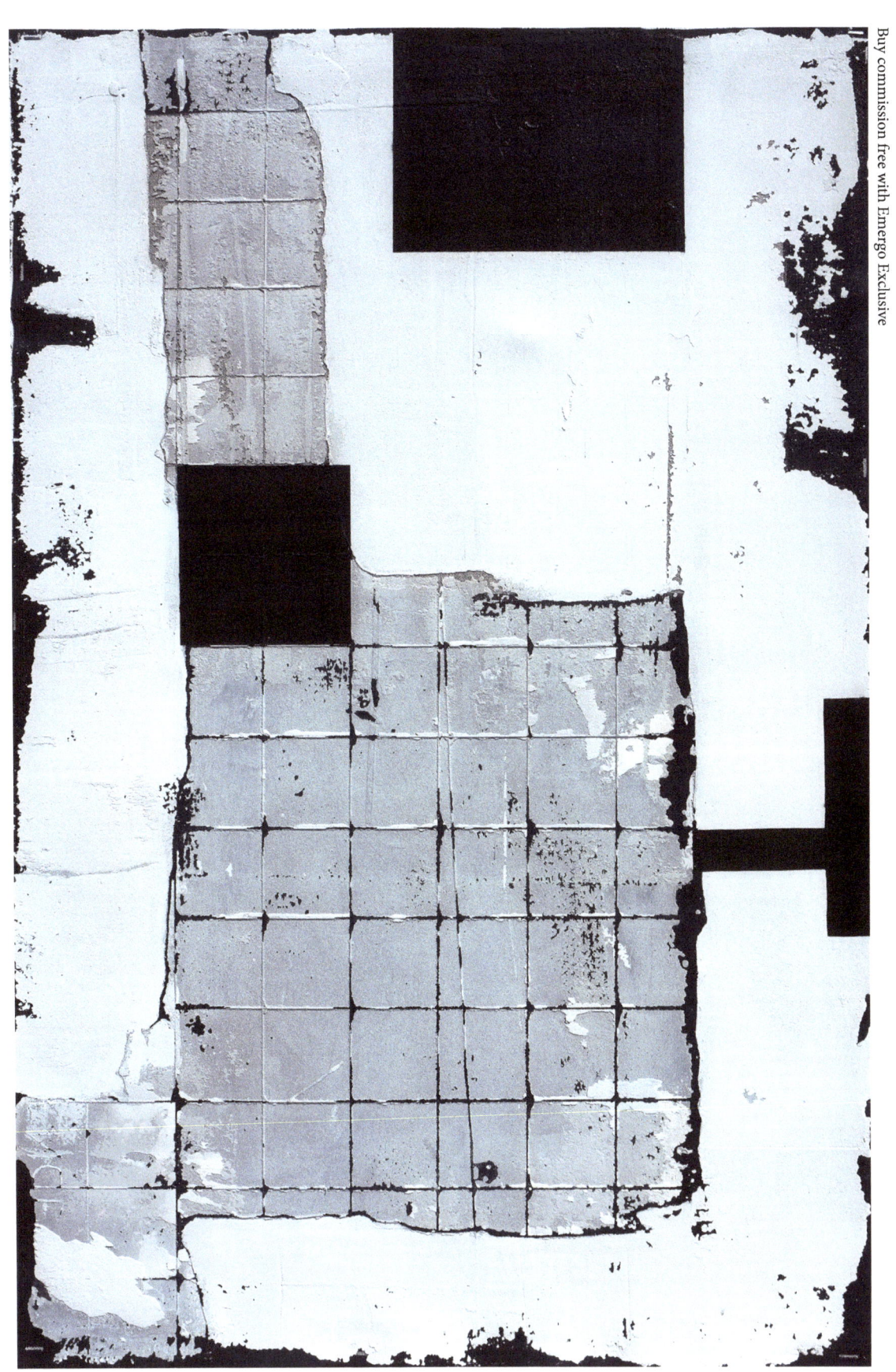

Untitled (Little Sasha)
Acrylic, Spray Paint, Household and Fiberglass on Canvas and Wood.

Untitled (Red shelter)
Acrylic, Spray Paint, Household and Fiberglass on Canvas and Wood.

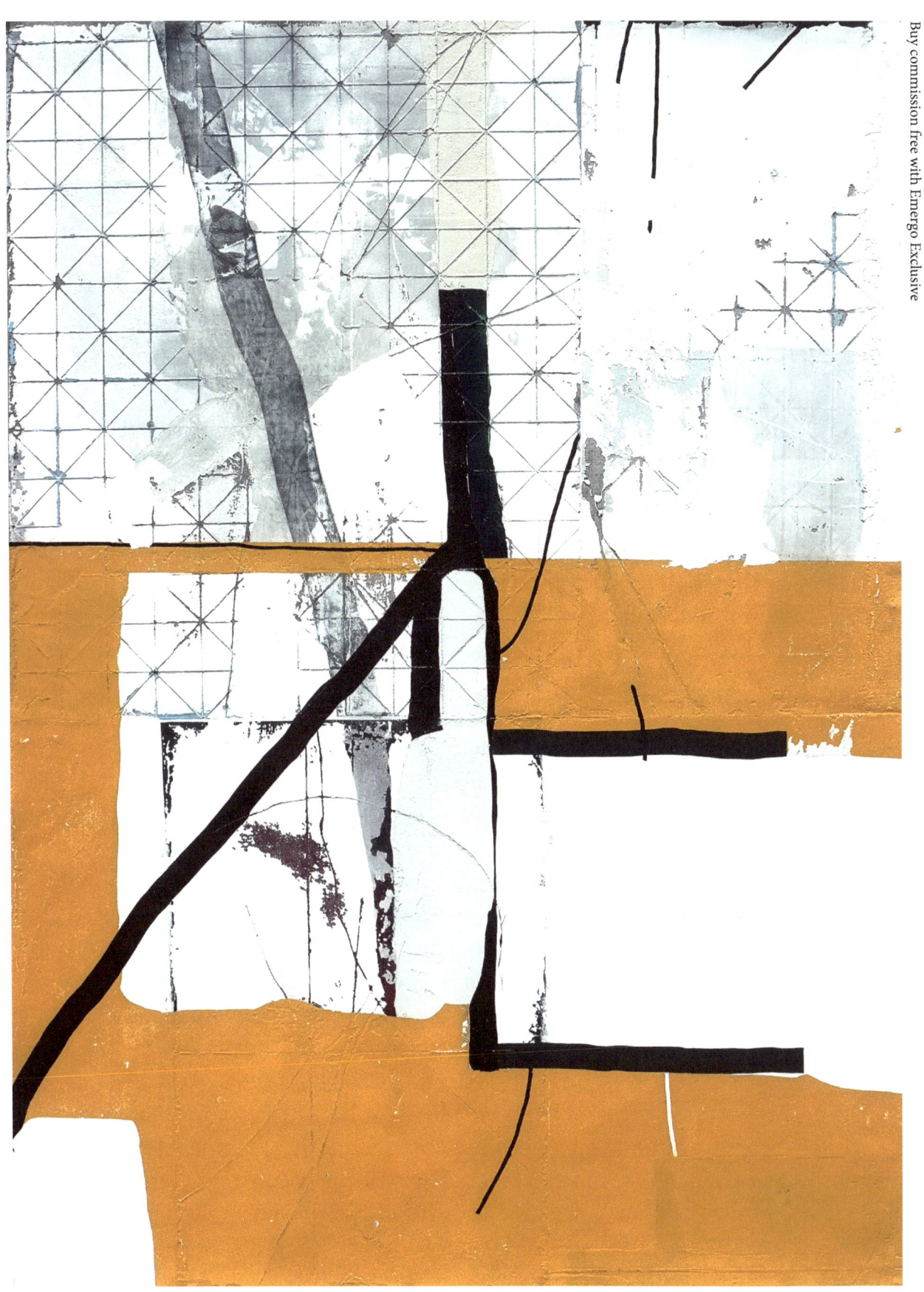

Untitled (Warm Gold)
Acrylic, Spray Paint, Household and Fiberglass on Canvas and Wood.

Koen Lybaert

Koen lives and works in Geel, a small Belgian country town about 40 km away from Antwerp. He lives in an old country house. He didn't study art in college, but went to the technical school. He worked in restaurants and bars, and later at a record store while creating art and music. Art was always a big passion, and Koen learned from other artists, self study, and practice. After an underground music career, he picked up painting again in 2008.

He liked to use oil paint as his main medium, but he uses acrylic, watercolor, gouache, ink, and resin as well. His oil paintings can take weeks or even months to be finished, as they consist of many layers, painted on one by one. He works on several paintings at a time so that the paint dry before the next layer is applied. With other mediums, Koen has a more direct approach, as they only need to dry for a few hours, or days at most. Especially watercolors are something you need to get right from the beginning. He says that the diversity of the mediums is something that keeps his mind and vision fresh. In his early 20s he even used metal, glass and wood in his artworks.

He likes to take trips to areas with unspoiled nature. Woods, lakes mountains, the sea and the most desolate landscapes serve as a constant source of inspiration for him. But even the more abstract approach by the medium itself can be a form of inspiration. The works of artists like Gerhard Richter, Claude Monet, Anselm Kiefer, and Mark Rothko are also inspirational. Mostly the ambience and technic of their works, helps Koen get inspired when he feels stuck.

In his artworks he tries to express his love for beauty and color. From simple monochromes to the complex multicolored work, it all comes down to how dorm and color touch his emotions. His work is a constant strive to create something beautiful.

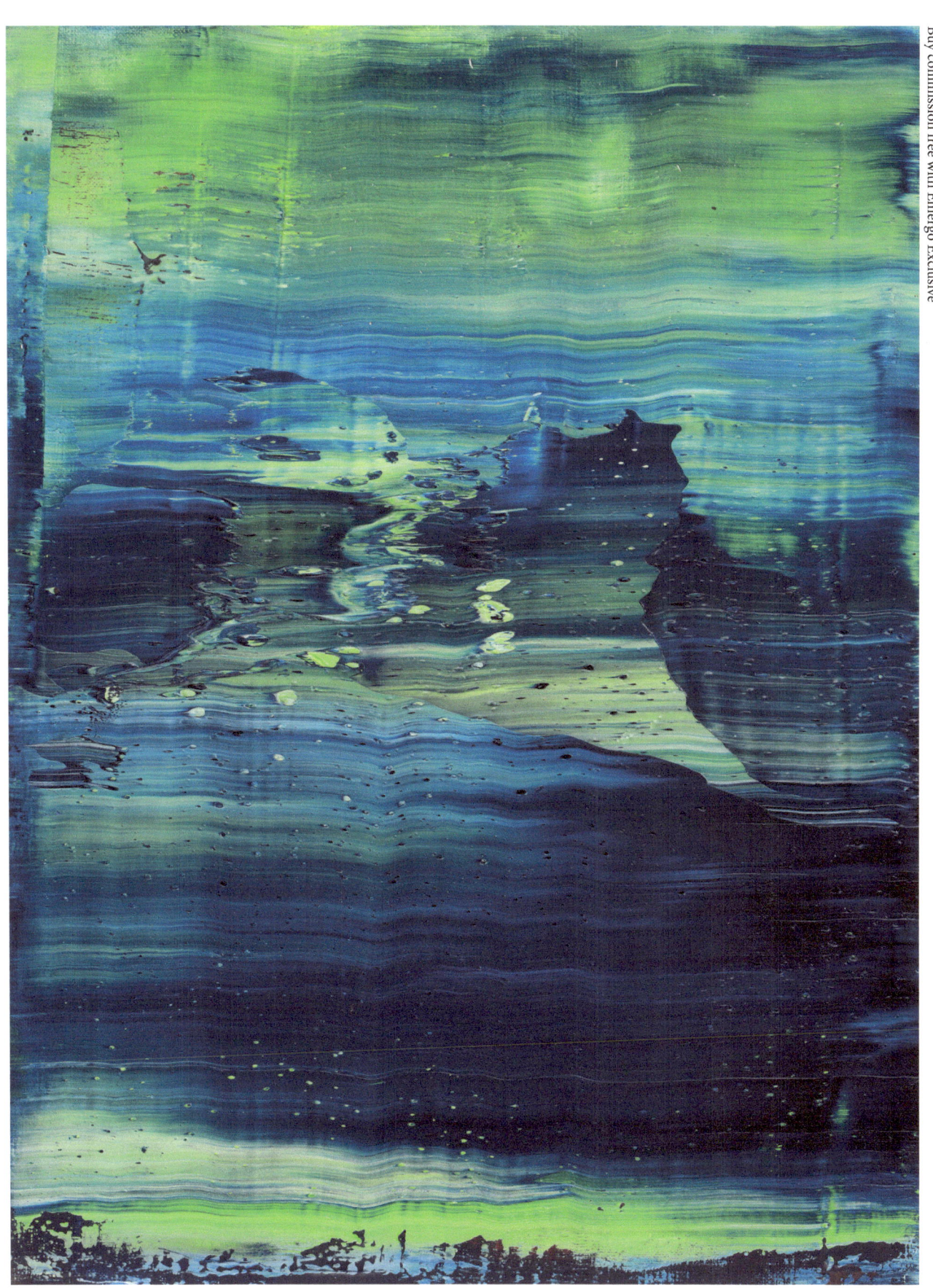

Giverny 138
Green en blue abstract, oil on linen paper. part of the Giverny series. An ode to Claude Monet.

Harvard Forest
Thick layered abstract, oil on canvas.

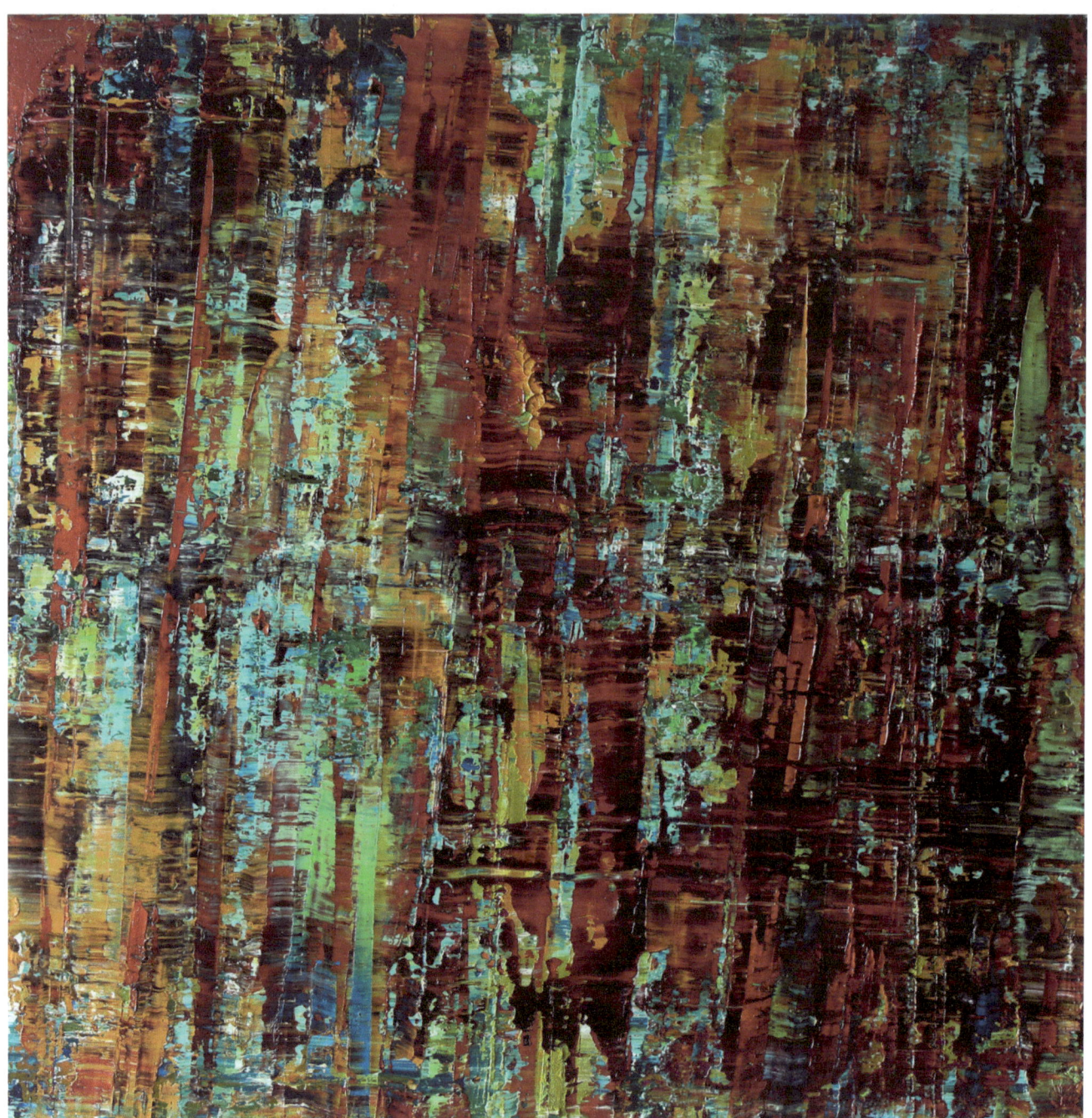

"My personal taste, my knowledge and skills evolve throughout the years. Therefore I like to take a look at my 'older' artworks from time to time and select those that still reflect my taste and vision. The ones that don't get selected are recycled/re-worked. For me an artwork is finally finished once it is sold. That means all previous works can disappear and become a new one after a period of time."

Koen's work is mainly abstract, but it varies from very minimalistic works to more complex ones. His focus was on abstract art as it comes closest to what he likes in art. He does like to bring in some elements that give some reference to nature. While his oil and acrylic paintings are the most abstract, his watercolor and gouache paintings are more focused on desolate landscapes. He also has a series of overpainted photographs, where he creates a mixture between abstract and figurative.

Color is his main concern when he starts working on a new painting. He tries to avoid painting with the colors straight out of the tube, but rather mix colors to create unique variations. As nature is one of his main inspirations, blues and greens are colors he likes to come back to most often.

Koen likes to explore all techniques, but for his abstracts he mainly works with squeegees. He only uses brushes during the first stage of the work. Then he uses all kinds of home made squeegees, made out of wood, metal, or hard plastic. Working with squeegees has been a long learning process. What seemed hard to handle first, evolved to an almost perfectly controlled skill. Each material has it's own characteristics. Each movement and pressure delivers a different kind of mark on the canvas. This way of working also brings a range of, as Koen likes to call them, "fortunate mistakes". Something that can be quite enjoyable when it enriches the work.

Koen loves making art. He loves everything about it. Right from the very start where the inspiration comes, and then the ideas come together in his mind. Starting to get the first strokes on a white canvas, and seeing how a simple white canvas can evolve into an artwork that excites him. Being a painter is also an antidote against the daily grind and harsh reality of the real world. He forgets about personal worries and the outside world. To him, painting isn't a daily struggle, as some artists refer to it, but rather helps his mind get into a state of zen. He needs to be all on his own, and he avoids distractions where possible. His art and the enjoyment it brings him, and the fact that it so many people love what he creates, is something he's very grateful for.

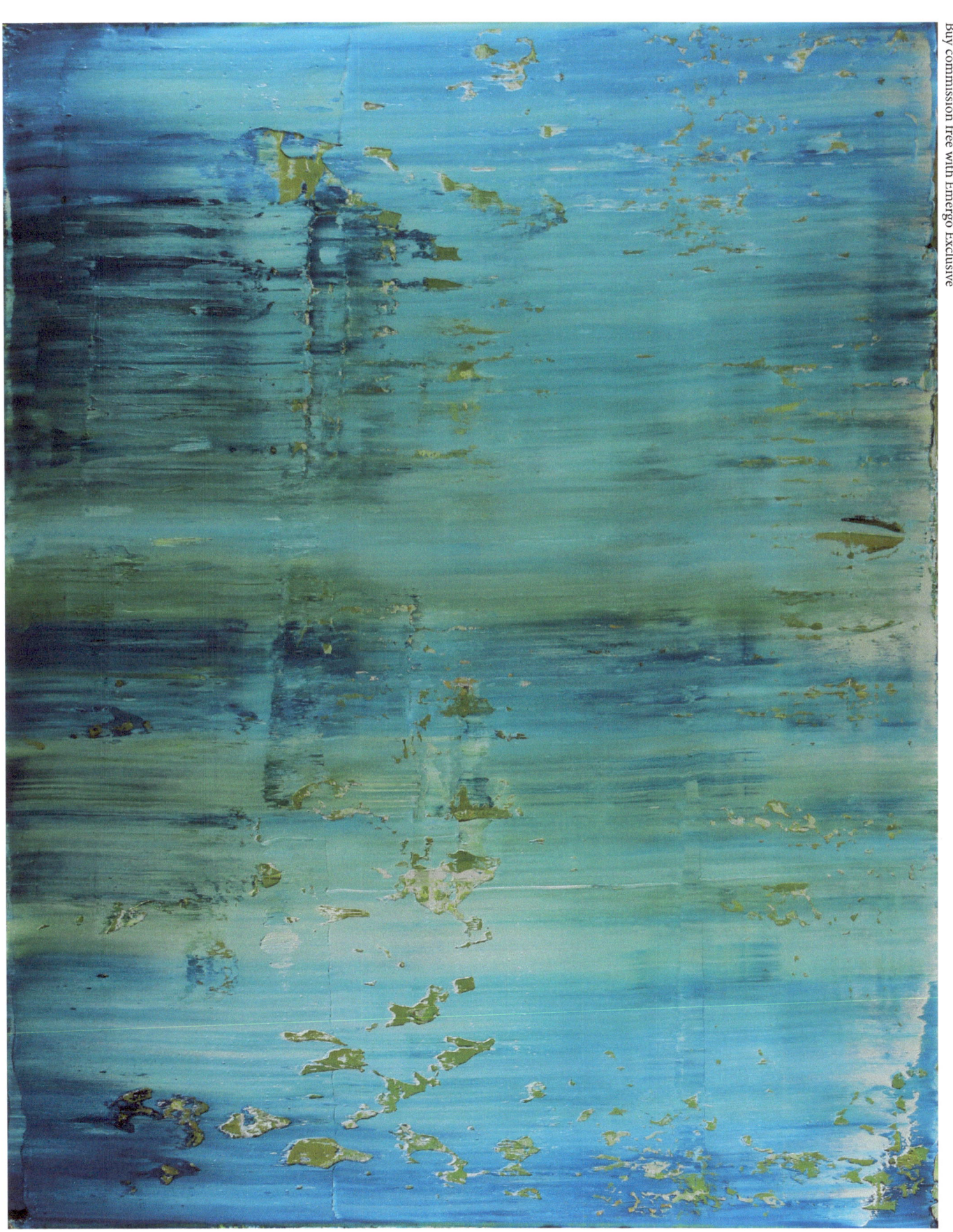

Changing seasons - Summer 02
Green and blue abstract, oil on linen canvas.

Frederic Belaubre

"The basis of the work of Frederic Belaubre, born in 1958 to a family of classical contemporary musicians, is the dynamic and harmonic enrichment, by colour in its semi-opacity or transparency, to a "subject" that is a static or dynamic shape, synthetic expression of an emotion.
The subtlety of a tonal or atonal harmony is translated into painting, the influence of the music is predominant. However, it is through a purely pictorial language that this research of unity in the complexity and simplicity of light is conducted. Various techniques are employed, oil on canvas, ink, acrylic on paper, powdered pigments, etc., in the service of a deep desire for inner transcendence of spiritual refinement. "

"On this beach of silence a froth of petals
flows back and forth to the blasts of storm. "

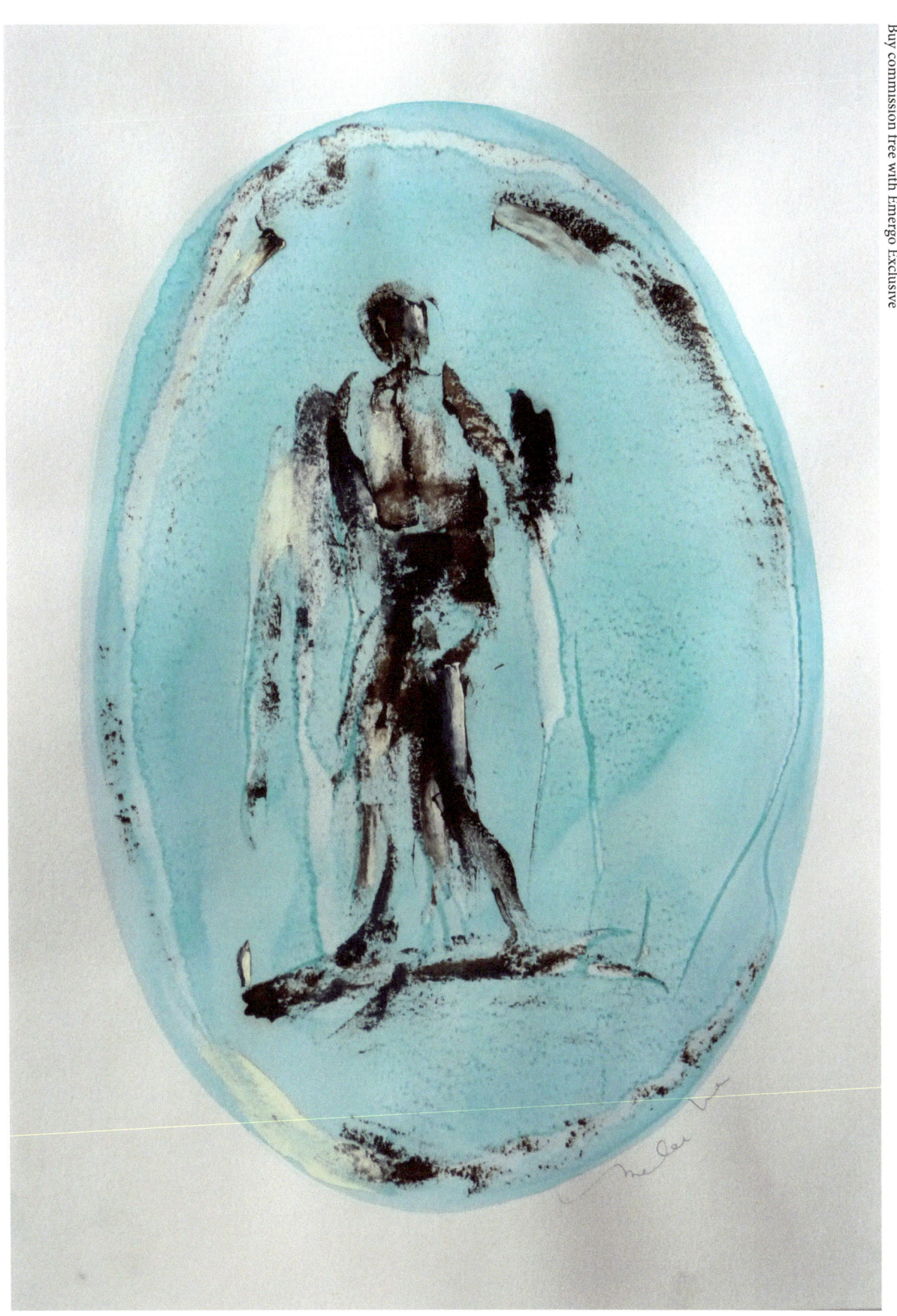

Ellipse #17
Original drawing on paper, created using oil paint, pencil and acrylics

Ellipse #21
Original drawing on paper, created using oil paint, pencil and acrylics

Ellipse #24

Original drawing on paper, created using oil paint, pencil and acrylics

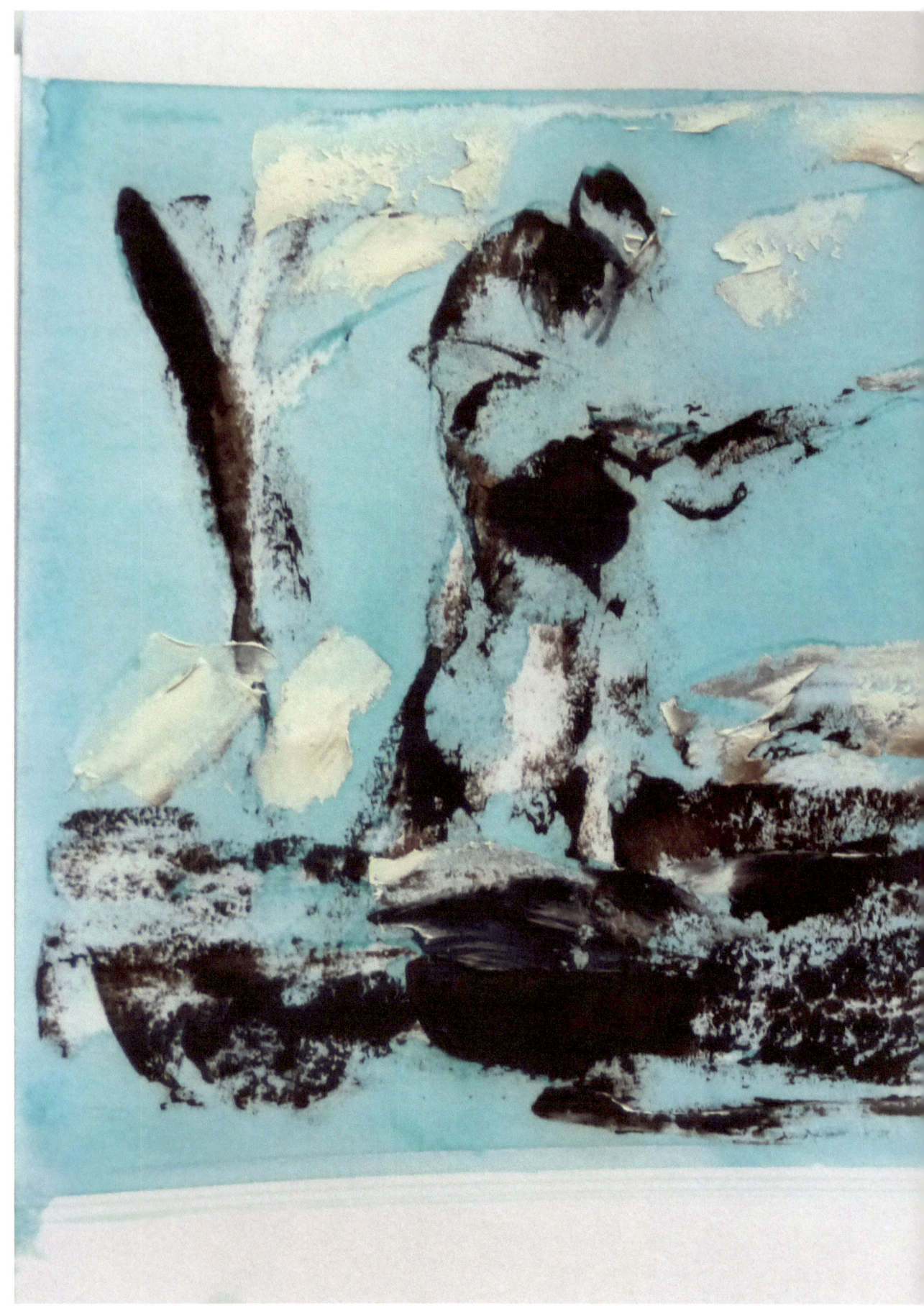

Ellipse #25
Original drawing on paper, created using oil paint, pencil and acrylics

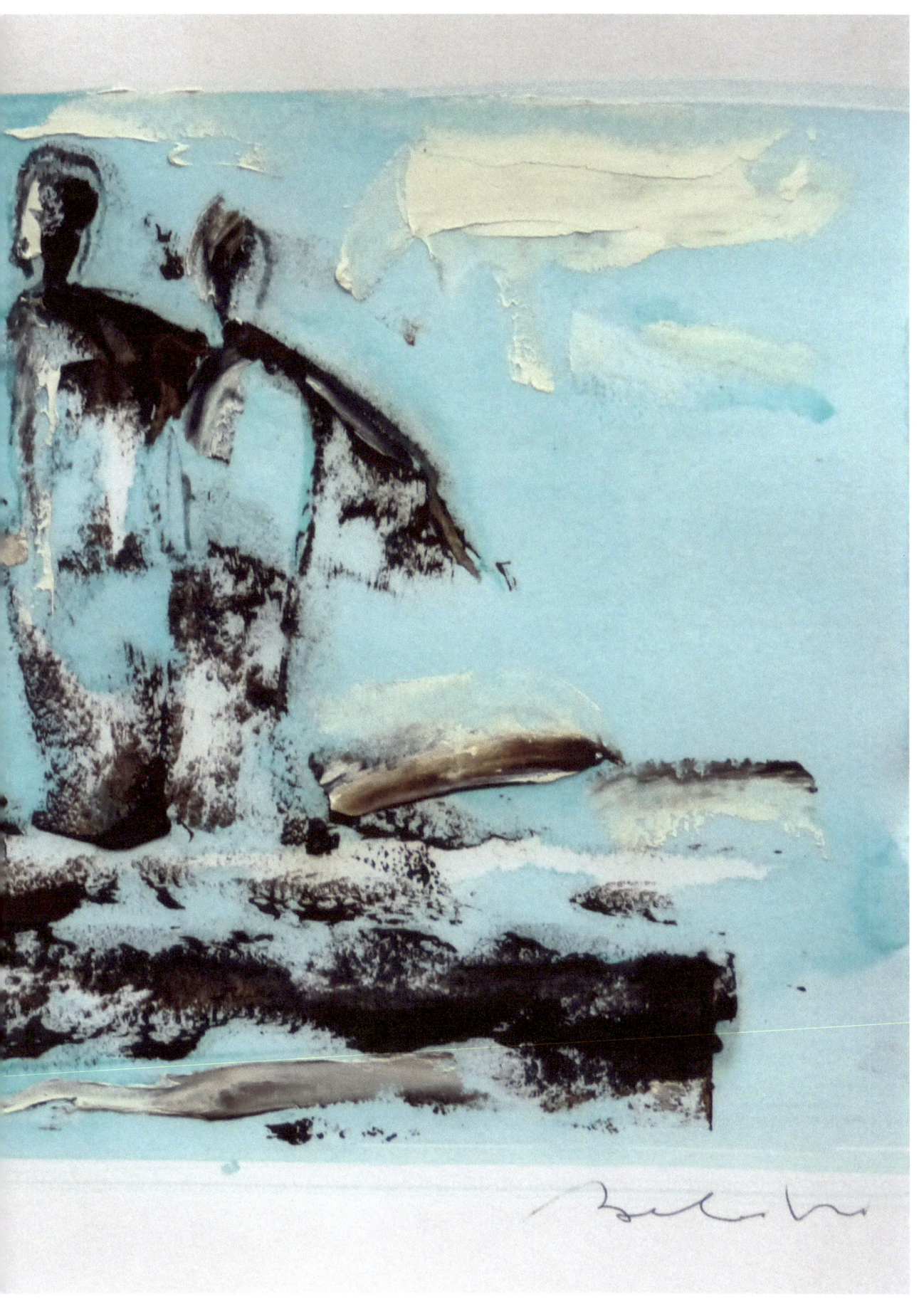

Ingrid Knaus

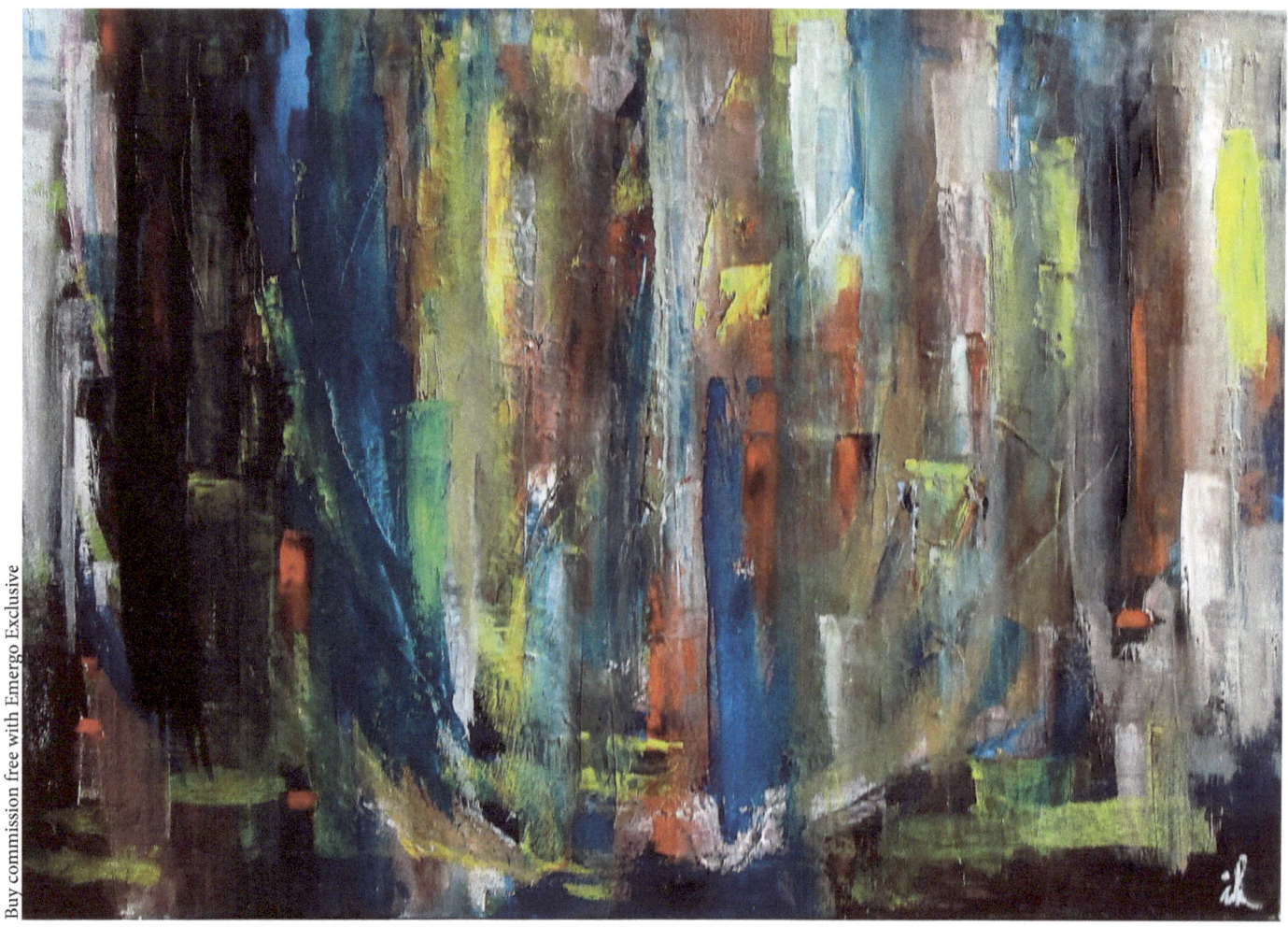

Second half of a winter afternoon, oil on canvas, 50 x 70 cm, 2016. Snowfall during carnival is a rather fixed phenomenon in our area. Within this period, coaches travel from Graz to Venice. Luckily, I´ve been to the Venetian carnival already, otherwise I would feel like I´d missed out on something great. I mainly spent my time walking in a gigantic crowd, watching every step I take, hardly seeing the floor. The walkway was a one-way system organized by a police man, including long breaks in standing position whenever the cross traffic was allowed to walk.

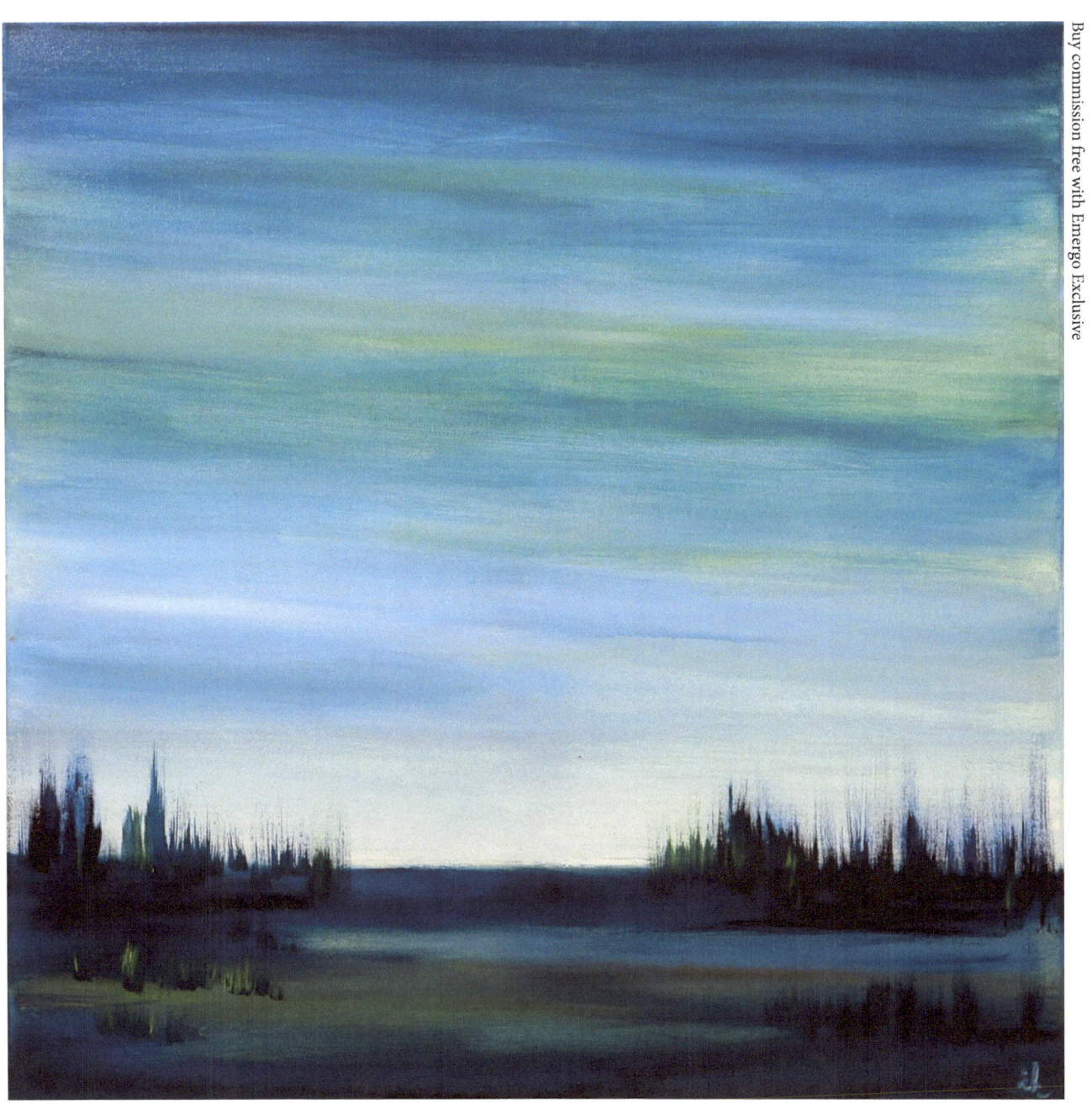

Meadow in clear morning air, oil on canvas, 70 x 70 cm, 2017. Within the huge fields were small trenches for watering. Individual farms were scatter apart; each farm surrounded by rusty agricultural machines.
In front of the buildings were high grasses, outgrowing the window sills.

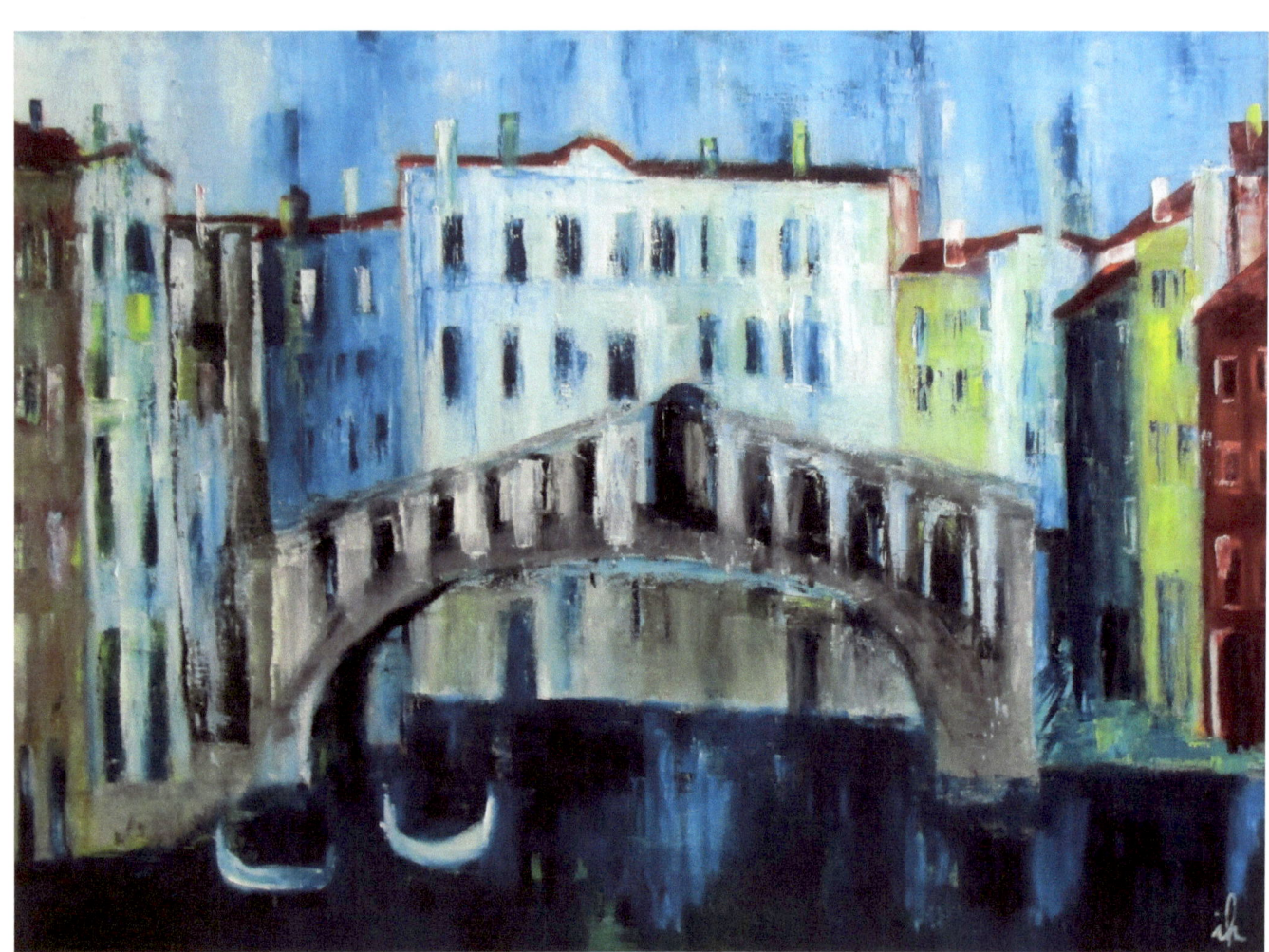

Venice, Rialto, oil on canvas, 50 x 70 cm, 2017. I´ve painted the Rialto Bridge a dozen times and still enjoy it. More than thirty years ago, I´ve seen it for the first time, where I painted it for a colleague. Within the years I´ve painted it so often that one could say that I wouldn´t exists without painting the rialto bridge from time to time. Still the main square disrupt my comfort zone.

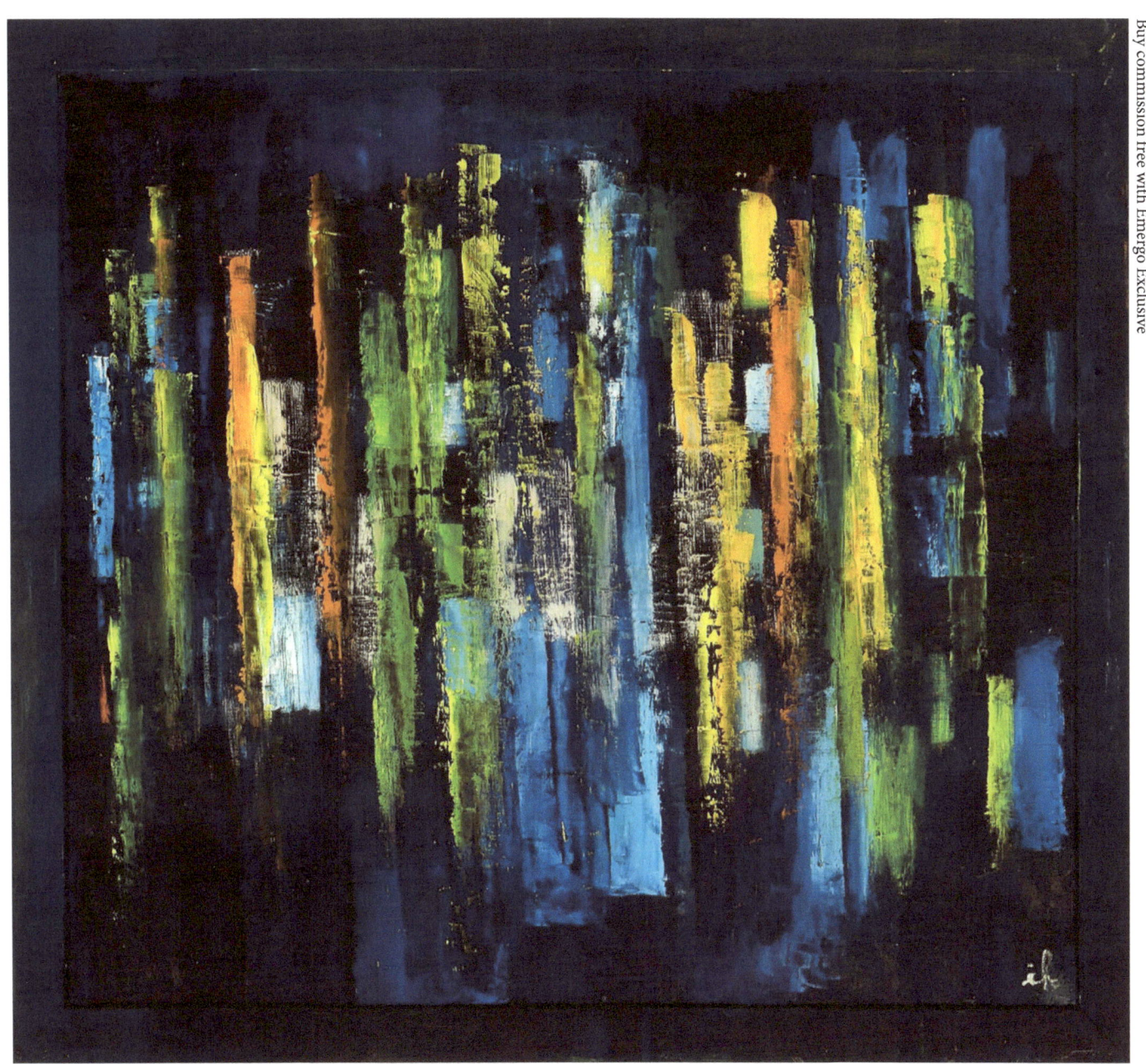

Chioggia, Bar Generale, oil on cardboard and wood, 52 x 62 cm, 2016. Back again at our apartment in Chioggia, we went to the Bar Generale on the evening just before our departure. Despite the cold wind blowing, we sat outside and I observed the reflections of the lights of the nearby island, multiplying on the sea surface.

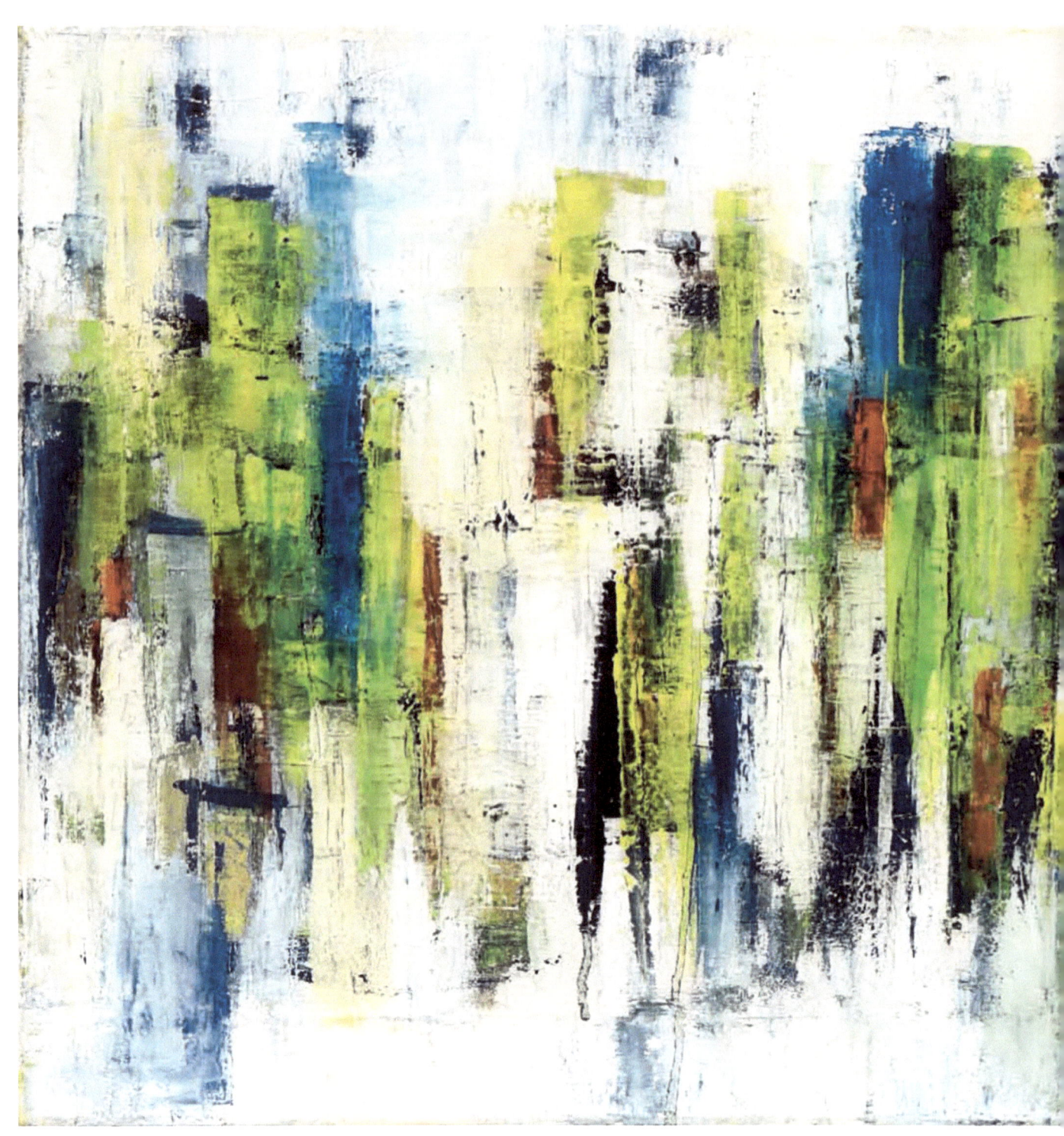

Winter sun southwest, oil on canvas, 19 x 60 cm, 2015. In steady anticipation of snowfall, I continuously feel relived in the morning when the sidewalk remains dry. Although the gritting and salting would only take me some minutes, the stand-by duty shakes up my daily routine. As soon as I stand in front of the canvas I feel like: here I am once again.

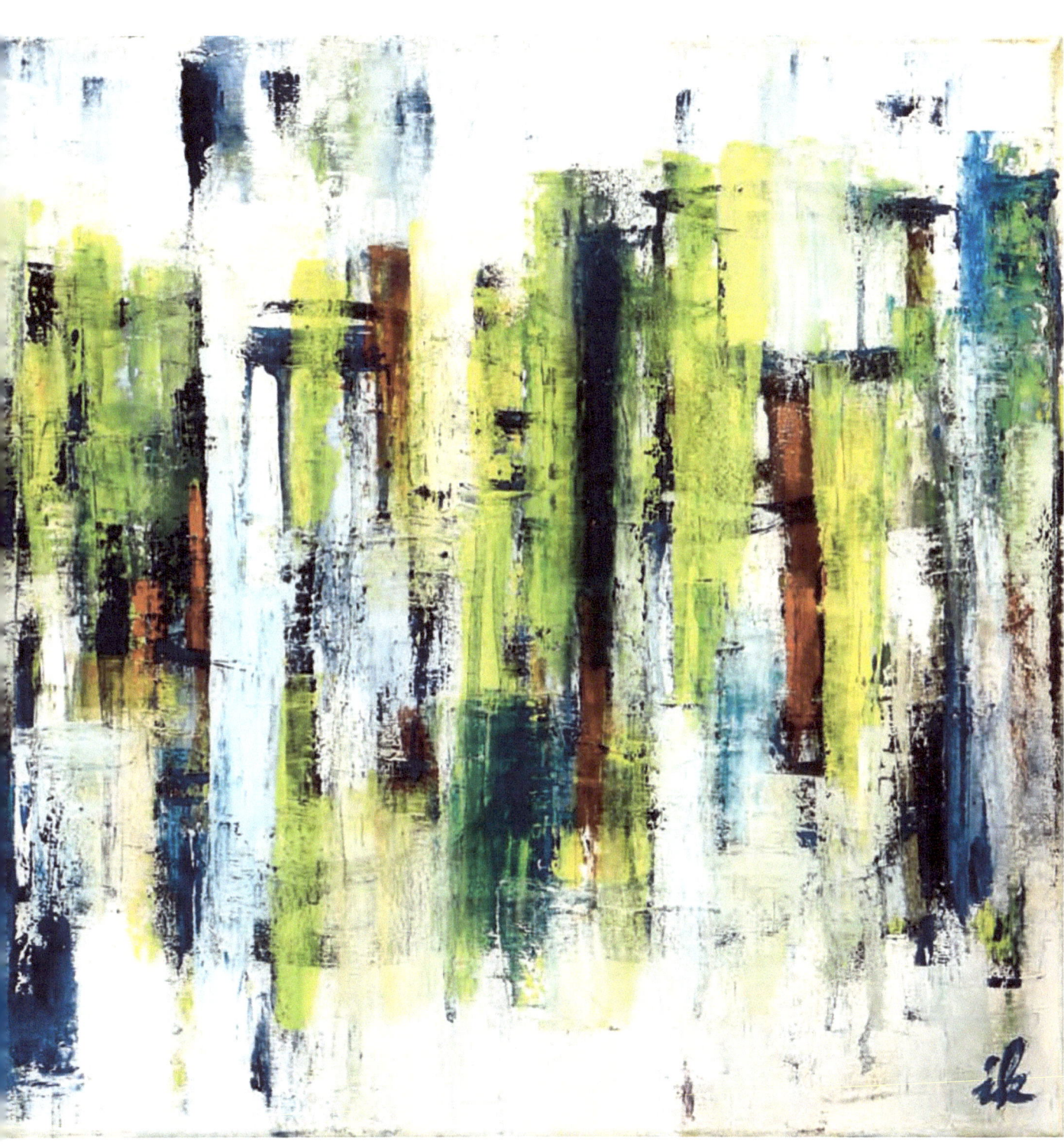

www.emergoart.com

www.ingramcontent.com/pod-product-compliance
Lightning Source LLC
Chambersburg PA
CBHW041303180526
45172CB00003B/946